STONE ROBERTS

Paintings and Drawings

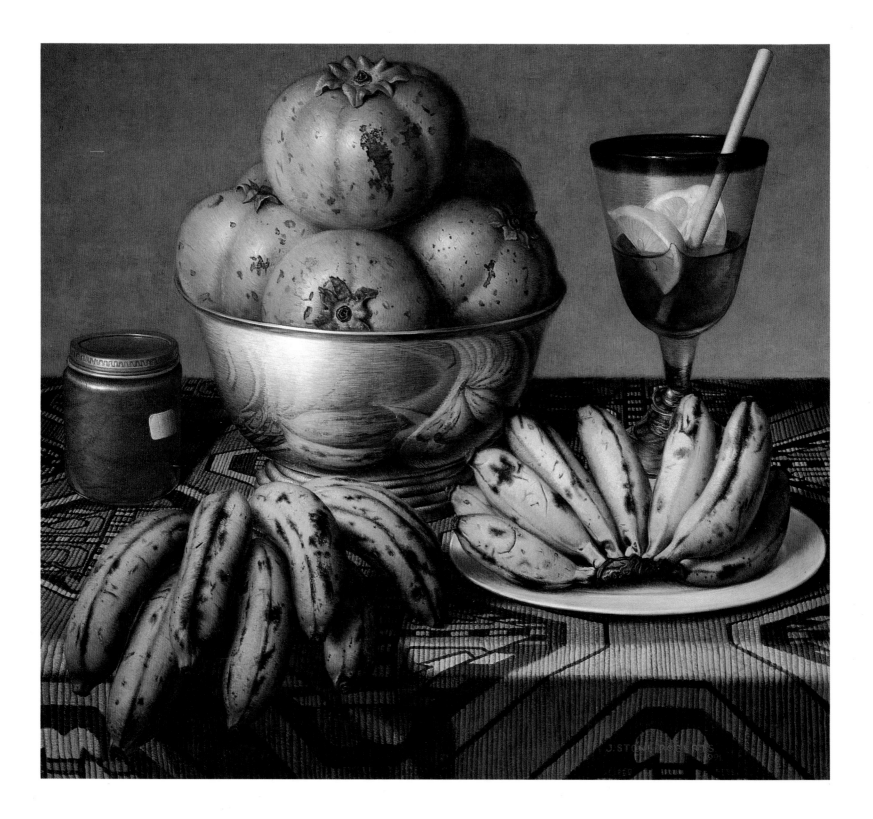

STONE ROBERTS

Paintings and Drawings

Essay by Charles Michener

Harry N. Abrams, Inc., Publishers

FOR BETSEY

Editor: Mark Greenberg
Designer: Carol Robson

Library of Congress Cataloging-in-Publication Data

Michener, Charles.
Stone Roberts : paintings and drawings / Charles Michener.
p. cm.
Includes bibliographical references.
ISBN 0–8109–2550–8
1. Roberts, Stone, 1951– —Catalogs. 2. Figurative art,
American—Catalogs. I. Title.
N6537.R5734A4 1993
759. 13—dc20 93–6930
CIP

Frontispiece
Still Life with Niños and Black Sapote
1991
Oil on canvas, 18¼ x 20⅛ in.
Collection Alex S. Jones and Susan E. Tifft

CONTENTS

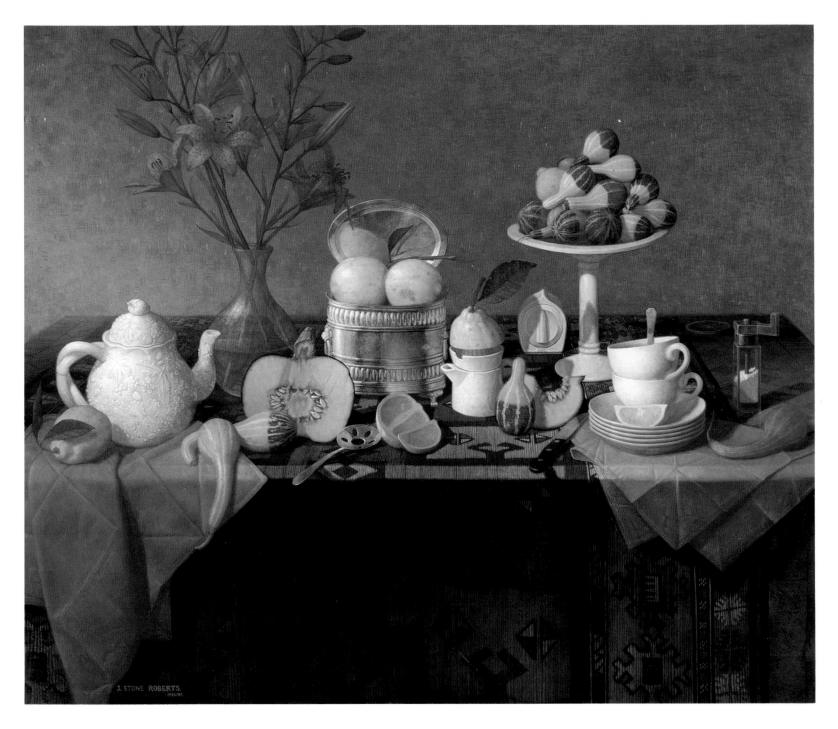

LEMONS, LILIES AND GOURDS
1986/87
Oil on canvas, 40 x 48 in.
Private collection

THE COURAGE TO PAINT

*L*emons, *Lilies and Gourds,* a large still life that Stone Roberts painted for his parents in 1986, occupies pride of place in his mother's living room in Asheville, North Carolina. At first glance it seems right at home among the fine antiques, silk upholstery, and oriental rugs, so well mannered are the harmonies of its meticulously rendered objects and luminous, mellow colors.

The more the eye roams the painting, however, the more problematic it becomes. Why does the light intensify rather than diminish as it travels away from the source across the changing whites of the Belleek china? What is the plastic kitchen timer doing there, set—somehow ominously—at zero? Why, for all the painting's surface amiability, does it seem so *tense?*

Clearly, as in the still lifes of seventeenth-century Dutch painting, some kind of "story" is being implied. But those arrangements of half-eaten fruit, flowers, and household objects were allegories with clear meanings—reminders of human *vanitas.* This painting only proposes the possibility of a narrative; the viewer is left to make up the story himself.

What is going on here? Are we in the hands of a young fogy who is trying to bring back the lost and dubious art of salon painting? Or is this yet another fashionable jester for whom academic painting is a put-on in disguise?

Neither assumption could be farther from the truth.

When Stone Roberts was about five (he was born in 1951), he climbed up on one of his parents' bookshelves and pulled down a slim illustrated volume called *Fifty Centuries of Art,* published by the Metropolitan Museum of Art. It made no difference that the book's reproductions of old-master paintings were of poor quality: the child's imagination was seized by these strange, inexplicable images. He recalls the "mysterious charge" he got from Castagno's *Martyrdom of St. Sebastian,* Veronese's *Mars and Venus United by Love,* and Cranach's *The Judgment of Paris.* When he asked his parents if Dürer's *Hare* was a real rabbit, he had to be told over and again that it wasn't real: Somebody had painted it.

Somebody had painted it. How could a rabbit be pulled out of paint? The notion that one could transfer what one *saw* onto a piece of paper astonished him. Even more astonishing was the way these artists—whose names meant nothing to him—created images that were powerful in and of themselves. "I never confused them with photographs," he recalls. "And I immediately knew they were not like the illustrations I saw in children's books. These were images that lived in a world of their own. I had little interest in whether they were telling a story or not. I was consumed by their sheer visual presence. And I knew somehow that they were very old. I felt it miraculous that they spoke so directly to me through time. Most of all, I was amazed that a person could put so much together out of his imagination and make it all *fit."*

The urge to create is, in good part, the urge to resolve. For what is art but an alternative reality in which the things that don't normally fit are made to fit? There was a lot about the childhood of Stone Roberts that didn't quite fit. Situated in the Blue Ridge Mountains, Asheville had prospered as a resort and health spa for wealthy Northerners, many of whom settled there. What it became wasn't one thing or another: not quite a small town, not quite a city (its population remains about 60,000); not quite Northern, not quite "Old South."

It was a place of sharply disparate cultures. There were the mountain people, rich in crafts and folk music. There was the exotic shadow of Black Mountain College, which refugee European intellectuals had made the spawning ground of the American postwar avant-garde. And there was Biltmore, a Loire Valley château, complete with its own "feudal" village, constructed at the turn of the century by the wealthiest Northerner of all, George Vanderbilt III. The largest private house in America, with a park laid out by Frederick Law Olmsted and sumptuous, art-filled rooms designed by Richard Morris Hunt, it was a fairy-tale vision of the Old World—right next door to the affluent neighborhood of Biltmore Forest where the Roberts family lived.

Inside that household there were disparate elements as well· Mrs. Roberts was the daughter of a distinguished family from Nashville, Tennessee, a well-settled woman who personified Old South poise and graciousness. Her husband, an Asheville native, was a self-made man who had put himself through medical school by the age of twenty-one and become a much-admired dentist.

"He was highly aesthetic," says Roberts of his father, who died a few years ago. "He loved classical music and beautiful things and he was an excellent draftsman. When I was little, I loved watching him make drawings, mostly of people, which I would then copy or trace. But he was a restless, unhappy soul—sentimental one moment, stern the next. His volatility ruled the family. Outwardly, we lived a well-ordered life—country club, church, charities. Within, things were a lot more complicated."

Despite their shared aesthetic interests, the son felt a strange antagonism from his father. Not until he was beginning to become an established artist—a choice of profession his father initially opposed—did he begin to understand why. One day the elder Roberts confessed that as a young man in the Depression he had dreamed of becoming a serious painter himself, only to abandon those dreams for a more responsible career.

From early on, Roberts excelled in school. At an age when his classmates were involved with sports, he retreated into the world of books, especially novels. It is not surprising that, in light of the premium his paintings would put on precision, balance, and resolution, he had an unusual aptitude for mathematics. He says that as an adolescent he "straddled the line between being the good son and being slightly unhinged." At Woodberry Forest prep school in Virginia he was a prefect, valedictorian—and someone who got himself into trouble by drawing satiric pictures of his teachers.

Roberts felt comfortable with the settings of his upper-middle-class upbringing, but uncomfortable with the rules that went along with them. He shone in art classes, but it never occurred to him—as it has for so many young Americans—to see art as a way out.

In 1969 he entered Yale, headed—he imagined—for a career in law or business. In the fall of his junior year he was accepted into a drawing class taught by the figurative painter William Bailey. Copying from old masters as well as from life, he saw—"under Bailey's very rigorous, very critical eye"—what drawing could do on the highest level. He went to the 1971 exhibition of Bailey's still lifes and figure paintings at the Robert Schoel-kopf gallery in New York and was struck by their "absolute seriousness."

Still, he was a generation apart. Bailey and his peers had kept the realist tradition alive against the waves of Abstract Expressionism, Conceptualism, and Minimalism. But a defining element of Bailey's work—like that of Fairfield Porter, Philip Pearlstein, Alex Katz, and others—was its ongoing dialogue with modernism. Aesthetically they had severely reduced their concerns. Emotionally their work was austere.

What Roberts had loved about Renaissance and Baroque painting was its formal richness, its emotional and psychological content, its sheer beauty of *paint*. In the 1960s, the concerns of art had been broken down into "problems"—problems of perspective, color, concept, and so on. Why couldn't there be painting that brought it all back together?

He looked for possibilities in a wide variety of work, ranging from Philip Guston's lyrically abstract painting of the fifties to Joan Mitchell's lush, coloristic abstractions; from Lennart Anderson's engaging figure compositions to the haunting interiors of Paul Wiesenfeld; from Francis Bacon's portraits, with their mix of art history and obsessive, unrestrained subject matter, to the psychodramas of Balthus.

In June 1972 he attended Yale's summer school for art in Norfolk, Connecticut. There, encountering students from art schools around the country and Europe, he realized how out of the mainstream his realistic drawings and paintings were. To his dismay, many of his classmates dismissed his work out of hand. It was an experience that left him deeply distrustful of the purported avant-garde.

At the Tyler School of Art in Philadelphia, where he did graduate work, perhaps the best thing that happened to him was being taken into the household of Julius Rosenwald II and his wife as a sitter for their dog. (The dean later said that he recommended Roberts to the Rosenwalds because he was the first art student in his experience to arrive at the school in coat and tie.) Julius Rosenwald's father had amassed one of the world's great collections of prints and drawings (then housed in the Avelthorpe Gallery), and Roberts was elated at being allowed to actually *hold* work by Dürer, Cranach, Rembrandt, Hogarth, Goya, Cassatt, Degas, Picasso, and Matisse.

The following June he got married and went to Rome to finish his fine-arts studies. There he studied with the painter Ronald Markman, who was visiting from the University of Indiana. With Markman's encouragement, Roberts began the difficult transition from drawing to painting.

Living in Rome brought him back to his earliest sense of art. Here, in the setting of its creation, art was an everyday reality. The experience was both exhilarating and sobering. He wanted to make paintings on the highest level, but he realized it would take him years to master even the fundamentals. How, in the meantime, was he to keep life and limb together? When he and his wife, Betsey, returned to New York, he didn't want to teach art and he didn't want to work in a gallery. He took a job in a Wall Street bank.

For five years Roberts worked successfully in corporate finance at Irving Trust. He rented himself a studio, where he only had time for drawing during odd hours. He did well at the bank but felt increasingly frustrated trying to balance two lives. Approaching thirty and on the brink of taking a new job in an investment bank, he agreed to what his wife had been urging him to do for years. In January 1981 he quit the bank and left New York for an old plantation house in the Mississippi Delta. "What was up for grabs," he says, "was whether I could fulfill who I was."

The idea to go was easy; starting to paint was something else. For months, while they renovated the house, Roberts "sat and *thought*." He tried his hand at still-life drawings, then a series of painted figures in grisaille. Before leaving for a month's trip to Europe he picked up a paperback copy of a recently published novel by Shirley Hazzard called *The Transit of Venus*. As much as any work of art can, it changed his life.

What was it about the novel that stirred his painter's ambitions so deeply? *The Transit of Venus* was manifestly in the grand literary tradition. Its cultivated heroines—two orphaned Australian women adrift in London and New York—could have stepped out of Henry James. Underlying the events was a Victorian sense of destiny: the ending—a plane crash—seemed as ordained as that of a novel by Hardy.

But this novel was unmistakably contemporary. For all their passionate entanglements, its characters were modern—irretrievably alone. Hazzard's descriptions of landscape were image-packed, her commanding voice intimately knowing of the characters, provocative with the reader. Roberts was overwhelmed by the novel's lucid complexity, its high-wire balance of tradition and idiosyncrasy. Here was a work of art that resonated the way he wanted his art to resonate. He returned to Mississippi with the courage to paint.

In 1981 the Philadelphia Academy of the Fine Arts mounted a landmark exhibition, "Contemporary American Realism Since 1960," that revealed the enormous diversity of painters who were emerging from the backwater of modernism. Roberts didn't see the show, but he bought and studied the catalogue. From its essays by Frank H. Goodyear, Jr., he copied down a number of quotes. Among them was this:

> Perhaps the reason that narrative painting has limited advocacy today is that artists are unwilling to take the ultimate anti-modernist position of allowing content to dominate form, recognizing, moreover, that the success of their narrative works may be heavily

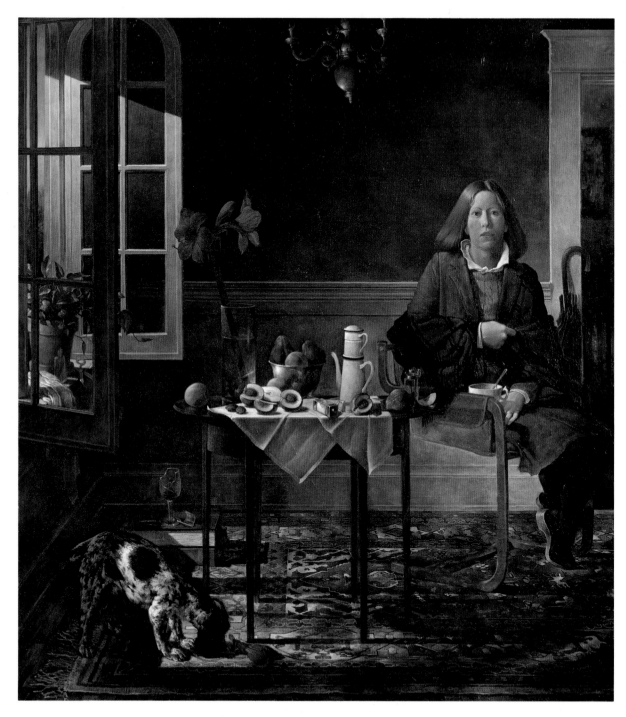

JANET
1982/84
Oil on canvas, 60 x 54 in.
The Metropolitan Museum of Art, New York,
Gift of Dr. and Mrs. Robert E. Carroll, 1986

dependent on borrowing historical pictorial conventions. . . . It is disquieting that so many realist artists, abundantly gifted in painting what they can see, stop at recording with visual accuracy, eschewing the delights and possibilities of a narrative voice.

In June 1982, *Newsweek* put William Bailey's *Portrait of S* on its cover for an article by Mark Stevens trumpeting "The Revival of Realism." Newsstands across the country took the issue off their racks in the face of complaints about a bare-breasted young woman, painted in Renaissance light, on the cover of a news magazine. For Roberts, the Goodyear catalogue and *Newsweek* article were beacons of encouragement. He plunged into his first large-scale realistic painting.

Janet was begun in April 1982 as a not-so-simple challenge: to paint a figure in an interior. Over the two years it took to finish it, Roberts worked its various parts as if he were writing a novel, trying to perfect one "chapter" (for example, the oriental rug) before moving on to the next (the still life), then going back and reworking them until they fit into his sense of a coherent visual drama. Some elements, such as the dog (Roberts's English cocker spaniel, Luke), were worked out first in drawing. Others, such as the still life, were painted directly onto the canvas. There was a great deal of over-painting. The figure of the young woman —a teller in a local bank—went from a casual, open pose to one of apprehensive self-protection. To heighten the sense of narrative possibilities, Roberts placed objects enigmatically—a broken wine glass, a fallen amaryllis blossom.

The result might be criticized as a patchwork for trying to combine so many subjects of traditional painting. Moreover, *Janet*'s rather muted spectrum of light and color shows that Roberts was still feeling his way as a colorist. But for a painting that is so clearly a process of self-education, it is remarkably convincing. Nowhere does it cheat or go slack, not even in the deepest shadows. The composition is beautifully worked out, with the diagonals making subtle counterpoint to the off-centered, frontal placement of the young woman and her haunting, surprised gaze. Best of all, *Janet* has what would become a hallmark of Roberts's work: an almost palpable *edge* derived from the tension between the certainty of the painting's formal resolution and the uncertainty it evokes.

While wrestling with this ambitious work, Roberts executed three smaller paintings in which he combined a reverence for nature's realities with an irreverence as to how they could be re-ordered in *his* reality. In *Mineolas Still Life*, completed in 1983, one sees the beginnings of an original dialogue among traditional pictorial elements. This still life is anything but still. Having placed the target of immediate interest—the bright orange mineolas—off to one side, Roberts established a precarious balance with the white shapes of crockery and napkin, then echoed that tenuous conversation in the colors and shapes of the oriental rug.

In *Parrot Tulips Still Life*, he pushed light and color with more confidence, creating an almost shocking play between pinks, oranges, and reds. In *Cantaloupe Still Life*, the busiest of the three paintings, he made a particular drama out of the tightly chaste form of the lemon and the violated open cantaloupe, oozing pulp and seeds.

Traditional still lifes were occasions for contemplation. These paintings take the viewer aback. Their homely objects, painted at one-and-a-quarter life-size, seem not so much eternal as eternally restless—about to pop right out of the picture plane.

It is not accidental that they are reminiscent of Caravaggio and his followers: Roberts decided to paint them after seeing an exhibit at the National Academy of Design in New York, "Still Lives from the Italian Golden Age." But they are anything but academic exercises. Roberts had taken note of Goodyear's observation that "much of the best contemporary still life painting lives in limbo between the artist's need to describe forms objectively and, at the same time, to transcend description." Already he had mastered one of the imperatives of the genre: to make the familiar strange.

In the fall of 1982 Roberts and his wife moved back to New York. Along with *Janet*, the three still lifes were subsequently accepted by the Schoelkopf Gallery. The smaller paintings found immediate buyers. Several months later, William Lieberman, director of twentieth-century art at the Metropolitan Museum, came into the gallery to look at several more established artists. It wasn't long before the Met acquired *Janet*—a painting by an entirely unknown artist—and put it on display at the inaugural show of the museum's new contemporary wing.

In two subsequent paintings, Roberts expanded his vocabulary. *Melon Still Life* introduced an elusive sense of whimsy in the shadow of a pewter coffee pot behind the smiling watermelon. In *Blue Cloth Still Life*, the fruit was treated with an expressiveness that flirted openly with the sexual.

In the summer of 1984, Roberts made human dialogue the actual subject of his second large painting, this one measuring six by seven-and-a-half feet, or twice as big as *Janet*. Marking the tenth anniversary of his marriage, *The Conversation* was inspired as well by the story of Dido and Aeneas—the first Roberts painting to find a starting point in classical mythology or the Bible.

Here, the episode in *The Aeneid* in which the Trojan prince tells the Queen of Carthage about the fall of Troy is updated to a social gathering in contemporary New York. While guests mingle ambiguously (it is not clear whether they are coming or going), a Cupid figure reaches for a bowl of fruit, a figure representing Rumor whispers to another guest. The lovers, played by the artist and his wife, Betsey—he in black tie, she reclining Odalisque-fashion—are caught not in a quarrel between the gods but in the problematic grip of their mutual regard, a relationship in which the balance of power seems very much in flux.

For someone who had only been painting seriously for two years, *The Conversation* was an audacious leap forward—from the one-figure scene of *Janet* to an immensely complicated tableau of ten figures. One of its challenges was to choreograph them with gestures that struck a balance between mythical and psychological time. Among other themes, the painting is concerned with masculine versus feminine—as expressed in the contrast between the sharp-elbowed Aeneas figure on the left and the cascade of womanly arms on the right.

Seeing *The Conversation* away from his studio, Roberts realized that its tonal range was more subdued than he had intended. In *Yellow Peppers* and *Lady Apples Still Life*, he consciously raised the key of his colors, pushing the yellows and greens as far as he could without losing control of the forms.

In *The Dressing Room*, his last work completed for his first one-man show at the Schoelkopf Gallery in 1986, he pulled it all together: a complex geometry of echoes and rhymes (the reflections of the Betsey figure in the mirror), whimsy (the hair dryer), a vibrancy of light and color, and a vaguely sexual aura, evoked by the implied presence of the male artist, who is unseen by anyone in this female world but his stand-in, the dog Luke.

Roberts had only recently come to appreciate the still lifes and floral paintings of Fantin-Latour for "their ineffable dialogue between what is perceived and how it is painted." His next three paintings, *Flowers in a Glass*, *Pansies and Goblet*, and *Winter Bouquet*, pay homage to the French master without a trace of nostalgia, so luminous and muscular is their rendering of these fragile, perishable blossoms.

When the Rosenwalds commissioned a painting from their former dog-sitter, he produced *Luke and Flowers*. It is a work that seems painted to both flatter and shock his fond patrons' cultivated taste—first with its virtuoso handling of the relationship between the plaid napkin and oriental carpet, then with its frank depiction of the dog, which recalls Stubbs for its articulation of an animal's physicality.

In 1988, Roberts was commissioned to paint a narrative from real life: the union of a husband, a writer, and his wife, a successful executive. What he created was a portrait of a marriage that may have been more probing than his subjects expected. The wife in *Portrait of the McNamees* is, as tradition dictates, in the foreground—not stiff-backed in a Victorian chair but seated on the carpet, half-demure, half-provocative, with the contents of her

briefcase spread out before her. Behind her stands her husband, leaning awkwardly toward his computer. The arch he forms suggests the husband's conventional, protective role. But these two marriage partners seem completely disconnected in their self-absorption. Only their passing black cat pauses to complete this odd family circle, acknowledging by the tautness of its tail and turn of head the disturbing undercurrents in the scene.

Portrait of the McNamees emerged out of many drawings, from which Roberts gave free rein to his choice of color. (Mrs. McNamee's business suit—in reality a light green—became fire-engine red.) By choosing to collaborate with the real world, Roberts opened himself further to elements that were out of his control, with results that feel less staged than his previous work.

In *Venus and Adonis* (1987–88) he achieved his most theatrical fusion of mythic and observable reality to date. Upon first glance, the painting seems like one of Peter Sellars's wildly irreverent stagings of grand opera. The goddess of love is now a prim New York matron, her lover a tennis player—judging from his tan lines. But one's inclination to dismiss this large work as a virtuosic folly is checked by the sheer intensity of the *painting*— from the hot splash of sunflowers to the veins of the Adonis figure, the prominence of which indicates that he isn't dead but merely asleep.

What keeps this odd tableau from tipping over into melodrama, what gives it real *gravitas*, is the remarkable orchestration of light. Unlike other contemporary mythic-realists, such as Alfred Leslie, Jack Beal, and Lennart Andersen, Roberts does not make classical or art-history allusions for instructional benefit. He regards mythical and biblical stories as "occasions" for paintings. But as his light—an eerie hybrid of the golden Italian Renaissance and a harsher New York day—falls across the scene, it suggests that the real death in this *Venus and Adonis* is the power of myth.

In his next figure painting, Roberts combined art history, biblical incident, and contemporary angst with a vengeance. *The Visit* subverts the traditional genre of card players, as exemplified by Caravaggio and La Tour, by recasting it with two young women in poses that suggest the visit of Mary to her cousin Elizabeth in the Gospel of St. Luke. One woman, ambiguously aggressive, has intruded on another, who is playing solitaire. The painting can be read as a narrative about two players in the gladiatorial game of yuppie materialism. At the same time that it luxuriates in the women's expensive garments, it implies that there is a good deal amiss behind their affluence. The disruptive dog suggests the monkey figure in paintings of antiquity— symbol of sensuality in check. The spilled wine recalls the blood of Jesus, Mary's son, and what would eventually befall Him. The jarring contrast of its crimson color (in the unspilled glass) against the visitor's magenta jacket is the epiphany in this prickly vignette of a discordant friendship.

By now, Roberts had established the pattern of his self-education: after each figurative drama he would replenish himself with still lifes in which he could push his handling of color, light, and form. In *August Still Life* he found a particular shade of blue to weave through the reds, yellows, whites, and greens so that they would exist in a state of perpetual agitation. In *Red Sensation Pears* he illuminated the fruit so that each pear has its own light source. Once again, what was being claimed was not so much nature's reality as the painter's reality.

In 1990, William Cecil, one of George Vanderbilt's two grandsons, commissioned Roberts to paint a family portrait to commemorate the centennial of Biltmore Estate. The canvas had to fit harmoniously at the end of one of Biltmore's great rooms. Besides depicting the family, another requisite was to show the accomplishments of the current generation in keeping the estate thriving.

For the better part of a year, Roberts worked on virtually nothing but *The William A. V. Cecil Family*. It would take a novella to put into words the enormous amount of historical, familial, and psychological information about Biltmore Estate and its present owners conveyed in this nearly seven-feet-square canvas. Among the work's many telling details (for example, the

placement of the Western boot of William Cecil's only son and heir between the father's black town shoes) is one masterstroke: the replication of a painting by the nineteenth-century American artist Seymour Guy called *Going to the Opera*. In this last formal portrait of the Vanderbilts, executed in 1873, the family is seen playing public parts in the social swirl of the Gilded Age. In the portrait of their descendants, it is the private selves that are on display. Each is dressed according to individual choice. Except for William Cecil, the patriarch in business suit, each seems uncomfortable with being himself and at the same time having to play such a public role as a member of the family. The Guy portrait hangs at the opposite end of the long room, adding its own voice to this complex dialogue between generations—especially in the figure of eleven-year-old George Vanderbilt, whose position at the table mirrors that of his grandson, Mr. Cecil.

Recently, Roberts has begun, with increasing boldness, to loosen some of the controls that imposed a certain stiffness on his earlier work. In the still life *Niños and Black Sapotes*, the objects seem carelessly arranged, the colors almost rude with each other —the garish red of the pimentos threatening to pull the whole composition apart.

Scissors, Frog and Garden Roses signals a new forthrightness. By its rigorous tension between the softness of the no-longer fresh roses and the sharpness of the implements that hastened their demise, the painting might be commenting on the artist's own ruthlessness as a painter.

Fruit, Kleist and Dahlias suggests still greater self-exposure. Among the unlikely objects forced into each other's company are an overcrowded bouquet of wayward dahlias, sensual mounds of fruit, a cheap red corkscrew, the matchbook from a New York restaurant with two burnt matches, a piece of Bohemian glassware etched with a running stag, and a paperback collection of short fiction by Heinrich von Kleist, the German Romantic writer whose great theme was the conflict between ideal order and earthly catastrophe.

Full of so many pointed references, the painting cries out for narrative analysis. One looks to the title story in the Kleist collection for clues and recalls that "The Marquise of O" concerns the mysterious pregnancy of a noblewoman who, during a time of war, is both raped and saved from death by an unknown officer. Perhaps the complex arrangement of disparate objects does not beg understanding but means only to ravish: to throw the viewer into a state akin to the voluptuous confusion experienced by the Marquise.

Roberts is not a programmatic painter. He builds his visual narratives out of ideas and memories, no matter how seemingly trivial. Some time ago, a friend joked that a misunderstanding with a man had left her feeling like "Potiphar's wife." This chance reference to the Old Testament story of Joseph fleeing the advances of the wife of Pharaoh's guard germinated in Roberts for nearly a decade. Over the years he collected representations of the story by such old masters as Guido Reni, Guercino, and Orazio Gentileschi. Ultimately, they became the foundations and echoes in a painting he completed in the fall of 1992.

The finished painting is called *Paul and Caro* after another inspiration, which occurred to him while making the preparatory drawing. Paul and Caro are the principal lovers in Shirley Hazzard's *The Transit of Venus*. One of the novel's climactic revelations is that their turbulent affair concealed still more turbulent affairs—a vortex of desire and betrayal. As the stars of this bedroom drama, he cast himself and his wife, Betsey.

Paul and Caro addresses the cross-purposes of self-exposure and concealment in marriage. While the Roberts/Paul figure struggles to put on his raincoat—which all but conceals him behind its broad, canvas-like expanse—the Betsey/Caro figure sits on the bed, wrapping her nakedness with a sheet and clutching her lover's tie as hostage. The dog Luke, third member of the Roberts household, has been suddenly awakened. It is a story that implies a great deal, sounds a note of brooding melancholy, and explains nothing. Like every Roberts story, it is not about revelation but reverberation.

With *Paul and Caro* Roberts leapt into the Baroque.

Whereas his previous scenes were played out in Renaissance perspective as if set behind a proscenium, this one takes place in a sharply tilted space wherein perceptual accuracy is slippery indeed. The figures are seen in subtly different perspectives, and the painter has taken considerable liberty with their relative scale. (It is clear that if the woman stood up, she would be a great deal taller than the man.) The new realism in *Paul and Caro* goes beyond the artist's sense of the world's instability to encompass his own precariousness as well.

Why, for all their dazzling assurance of construction, do these paintings seem, in themselves, so precarious? At the heart of this paradox is another paradox. Although they are as educated, sophisticated, and well traveled—at least to Europe—as any art of our time, these paintings are inescapably American. In their exactitude with objects, natural or man-made—in their obsession with the *thingness* of things—they are as American as the heightened realism of Harnett and Peto or the soup cans of Warhol. In the painter's insistence on limiting himself to painting *what* he sees with equal attention to every figure and object, they are as "primitive" as the anonymous portraits of Colonial New England and rural landscapes of Grandma Moses. Their sense of the luminous world beyond art and their labor to make that world more luminous through art is as imbued with wonder as the Hudson River School vistas or the drips of Jackson Pollock.

The driving concern in Roberts's art seems, more precisely, *southern* American in its yearning to arrest the reckless momentum of a democratic society that creates such a spiritual vacuum— the force of which, as Alexis de Tocqueville wrote, makes "every man forget his ancestors . . . throws him back forever upon himself alone and threatens in the end to confine him entirely within the solitude of his own heart." What may be most American of all about Roberts's paintings is their urgency to connect.

As of this writing, the latest cartoon on his drawing board is inspired by the New Testament story of the Flight into Egypt. It casts Roberts himself as hovering angel, which is perhaps what every artist in this unruly universe aspires to be. This angel is no transcendant emissary, but an earthbound, bespectacled fellow in a raincoat—a man in his early forties who refuses to dress the part of the alienated modern artist, who still looks like a banker.

And who looks not unlike another artist who worked in a bank, a poet who combined a yearning for past harmonies with a clairvoyant's awareness of present disharmonies. Talking about why he paints what he paints, Roberts cites this passage from the "East Coker" section of *Four Quartets* by T.S. Eliot: "Home is where one starts from. As we grow older / The world becomes stranger, the pattern more complicated . . ."

PLATES

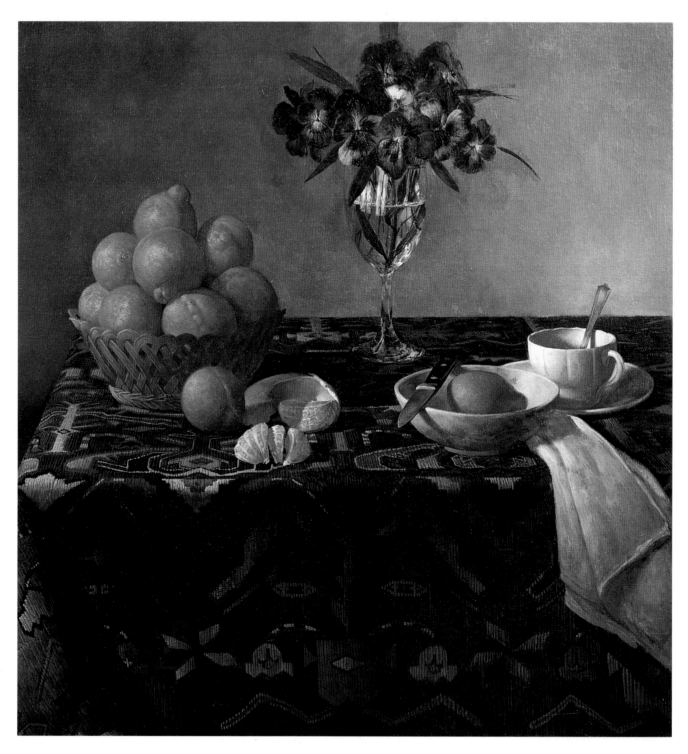

MINEOLAS STILL LIFE
1983
Oil on canvas, 32 x 30 in.
Chemical Bank Collection, New York

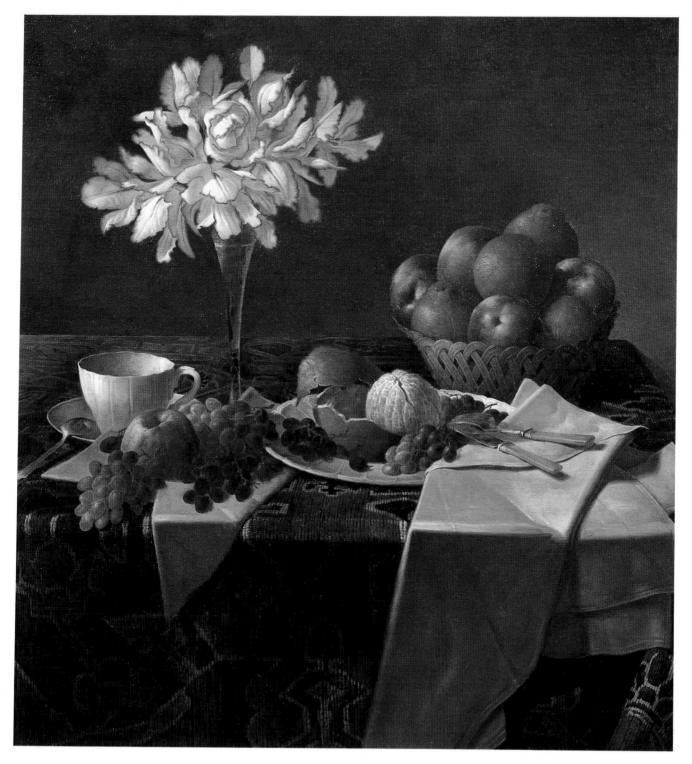

PARROT TULIPS STILL LIFE
1983
Oil on canvas, 32 x 30 in.
Collection Carll and Diane Tucker

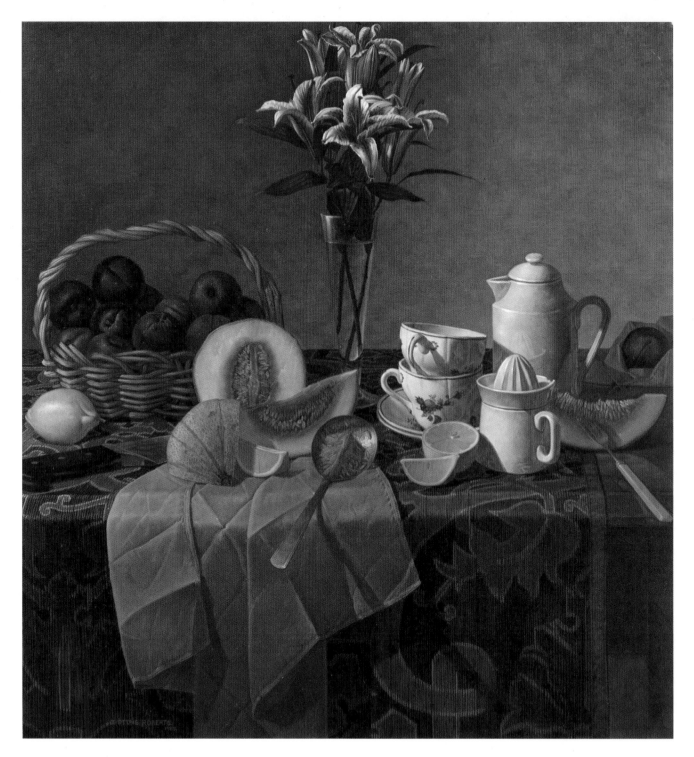

CANTALOUPE STILL LIFE
1985
Oil on canvas, 32 x 30 in.
Private collection, New York

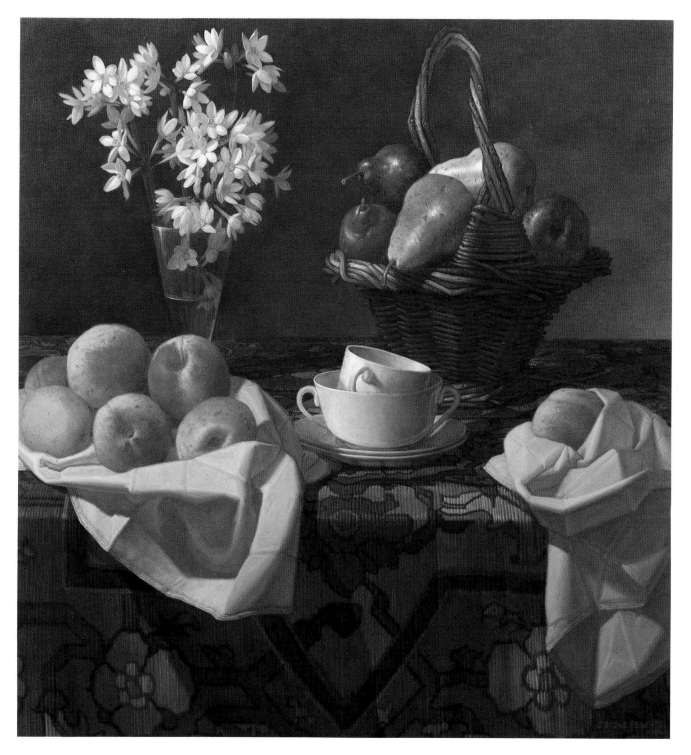

PAPER-WHITES STILL LIFE
1985/86
Oil on canvas, 32 x 30 in.
Private collection, New York

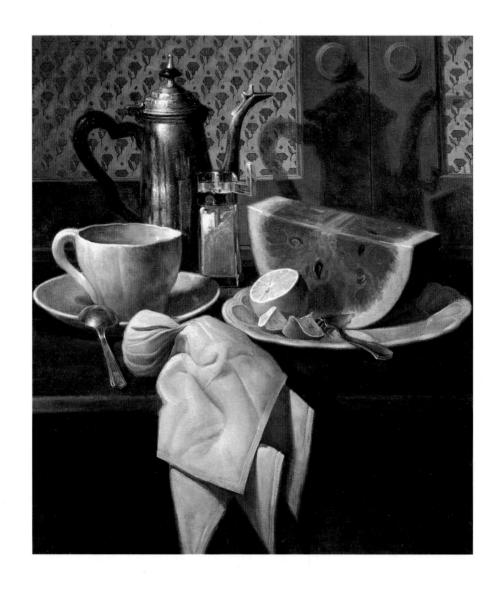

WATERMELON STILL LIFE
1983/84
Oil on canvas, 18 x 16 in.
Collection Allison and Donald Innes

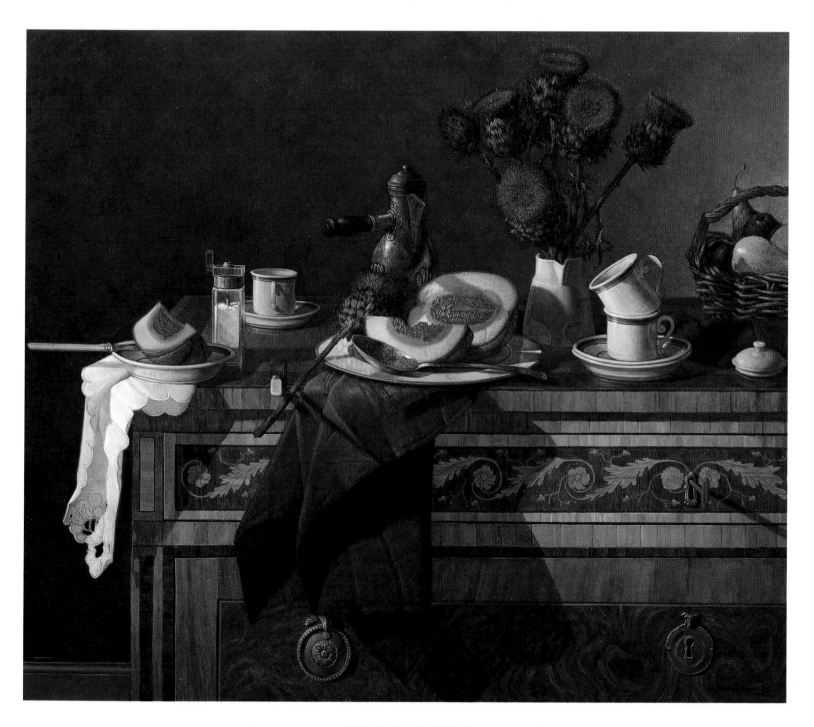

THE ITALIAN CHEST
1985
Oil on canvas, 28 x 33 in.
Private collection

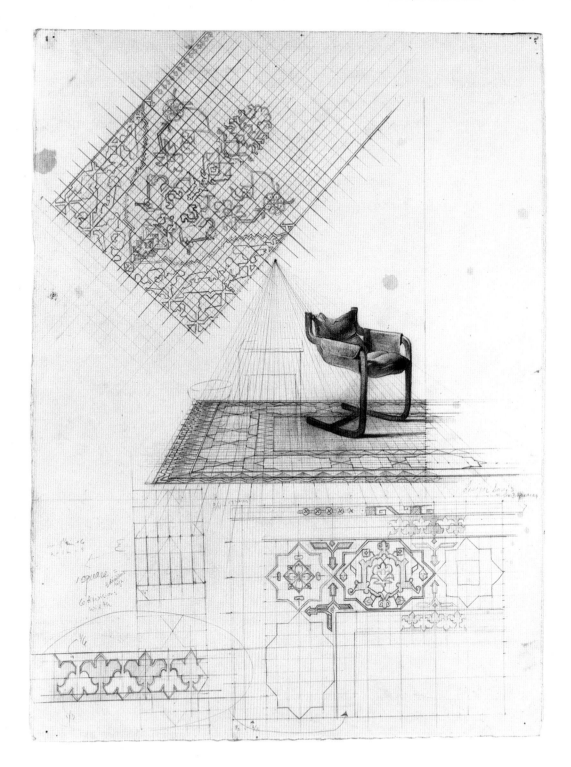

Perspective Study for JANET
1982
Pencil on paper, 15 x 11⅛ in.
Courtesy Salander-O'Reilly Galleries, Inc.

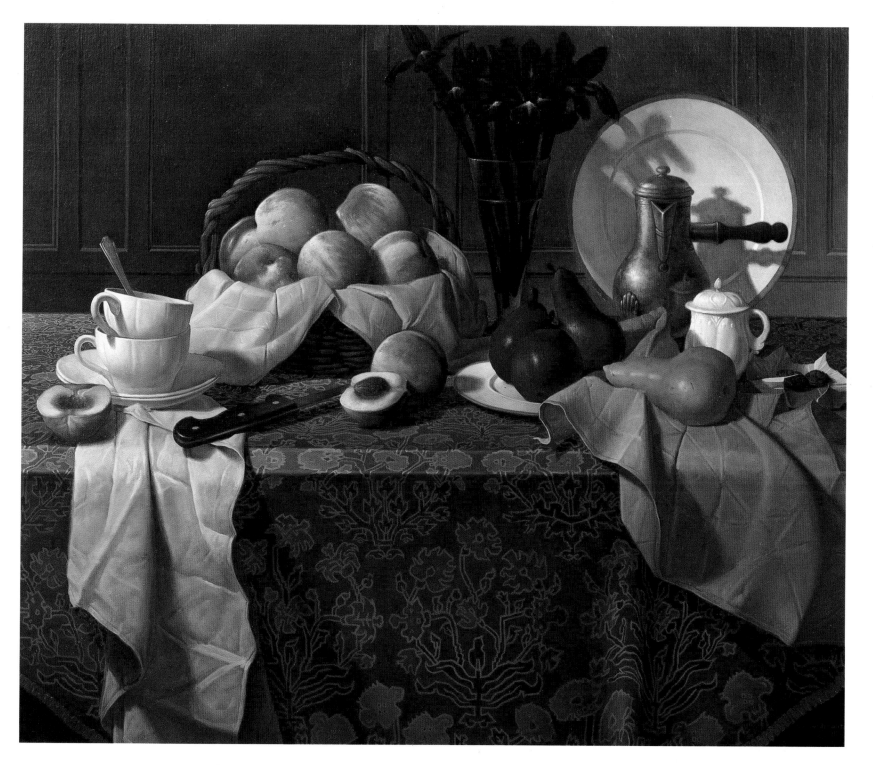

BLUE CLOTH STILL LIFE
1984
Oil on canvas, 30 x 36 in.
Private collection, New York

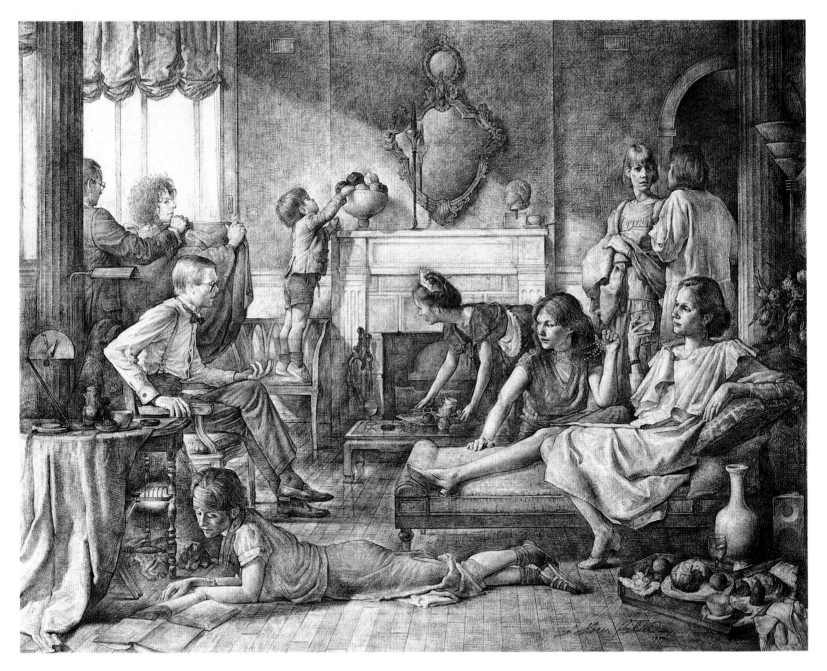

Cartoon for THE CONVERSATION
1984
Pencil on paper, 16 x 20 in.
Private collection, New York

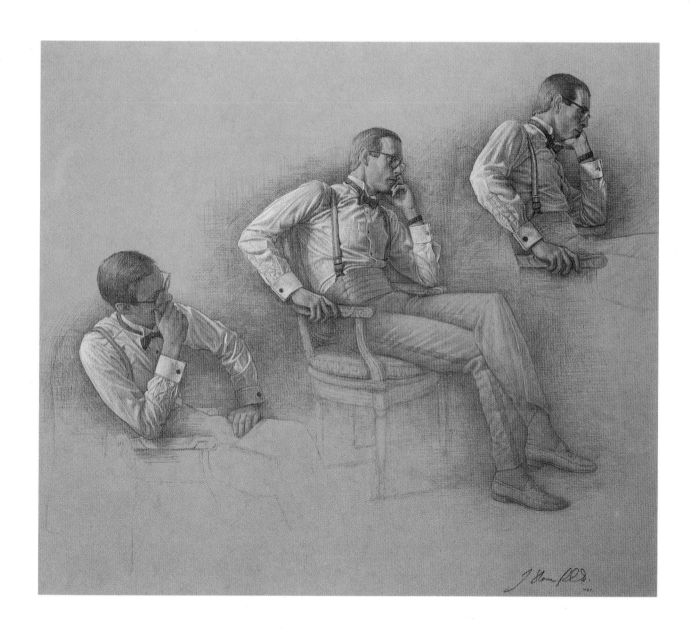

Study for THE CONVERSATION (*JSR*)
1984/89
Pencil on tinted paper heightened with white, 14½ x 17 in.
Private collection

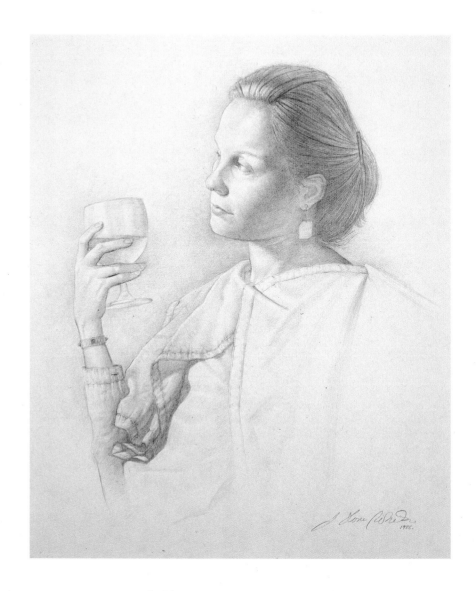

Study for THE CONVERSATION (*EMR*)
1985
Pencil on paper, 12¼ x 10¼ in.
Private collection, New York

Study for THE CONVERSATION (*Chintz Pattern*)
1985
Colored pencils on paper, 9⅝ x 7 in.
Private collection, New York

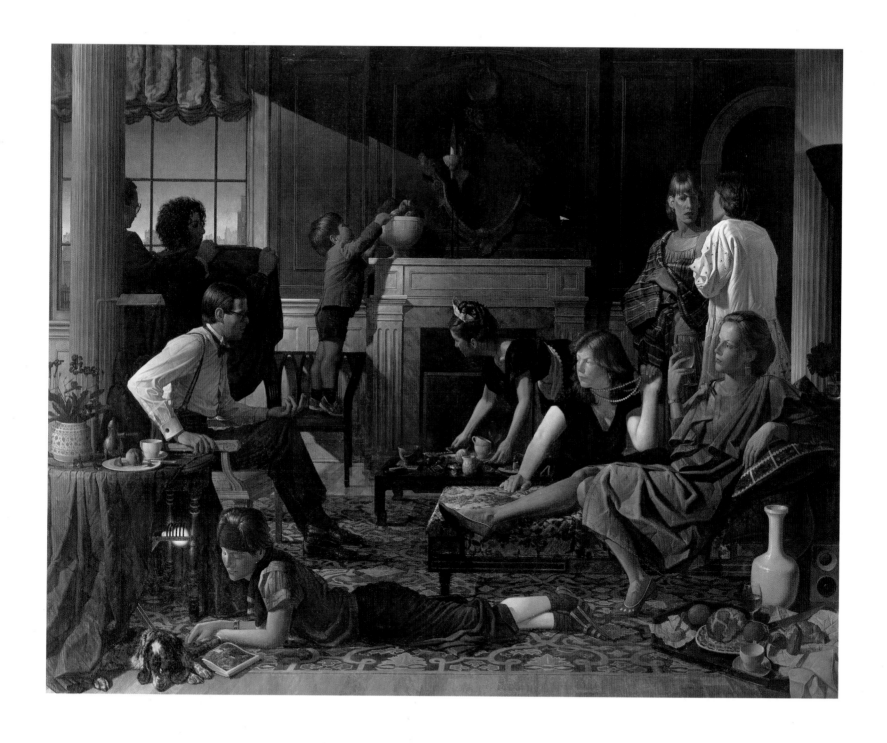

THE CONVERSATION
1984/85
Oil on canvas, 72 x 90 in.
Collection Mr. and Mrs. Frederic D. Wolfe

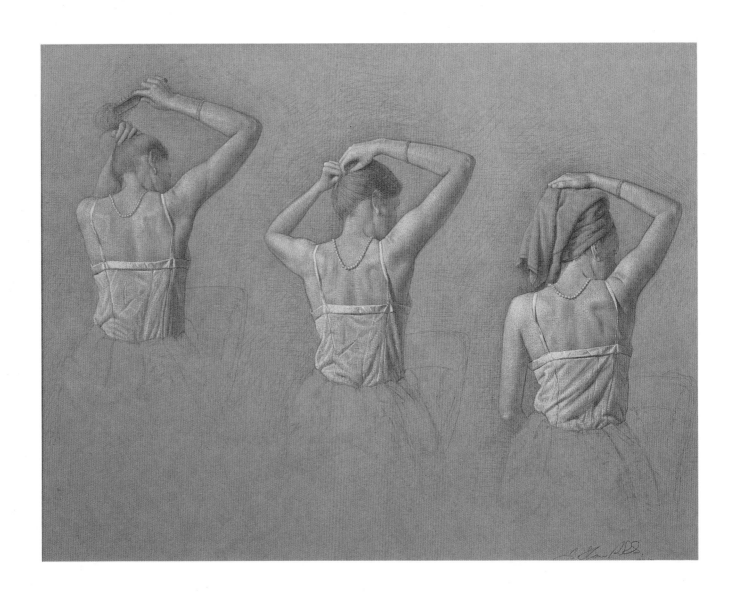

Study for THE DRESSING ROOM (*EMR*)
1986/89
Pencil on tinted paper heightened with white, 13⅛ x 17⅛ in.
Collection Carl Spielvogel and Barbaralee Diamonstein-Spielvogel

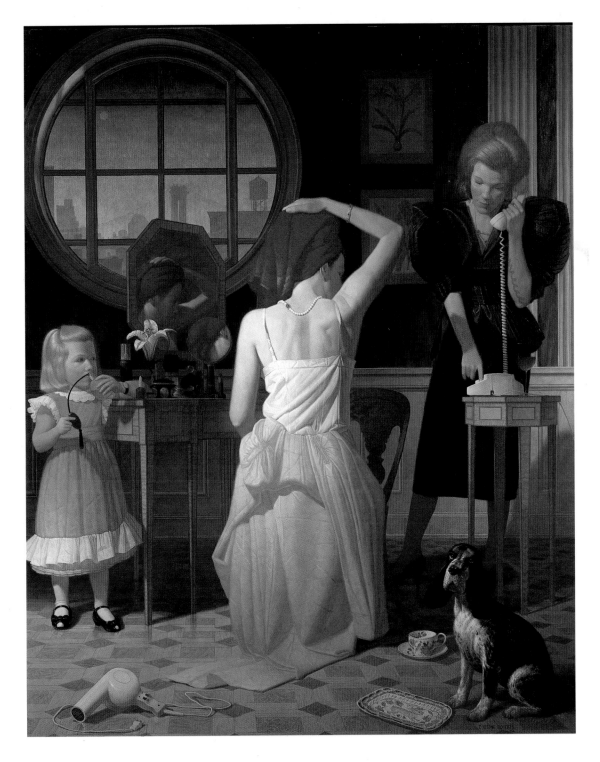

THE DRESSING ROOM
1986
Oil on canvas, 60 x 48 in.
Collection Mr. and Mrs. Richard L. Menschel

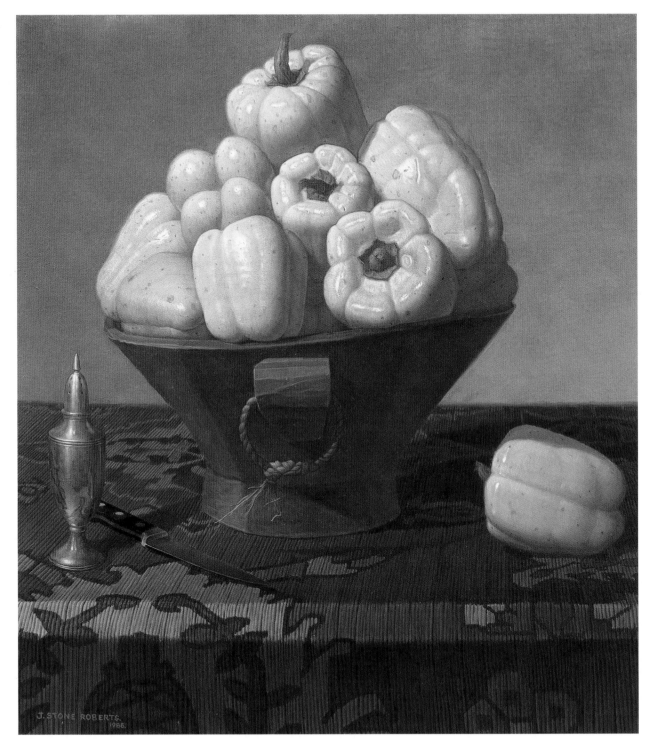

STILL LIFE WITH YELLOW PEPPERS
1986
Oil on canvas, 22 x 20 in.
Wellington Management Company Collection, Boston

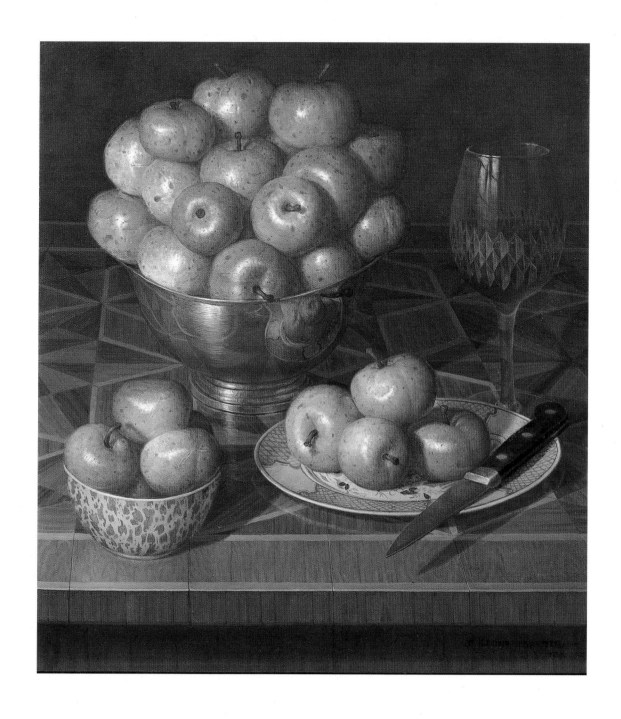

STILL LIFE WITH LADY APPLES
1986
Oil on canvas, 18 x 16 in.
Private collection, New York

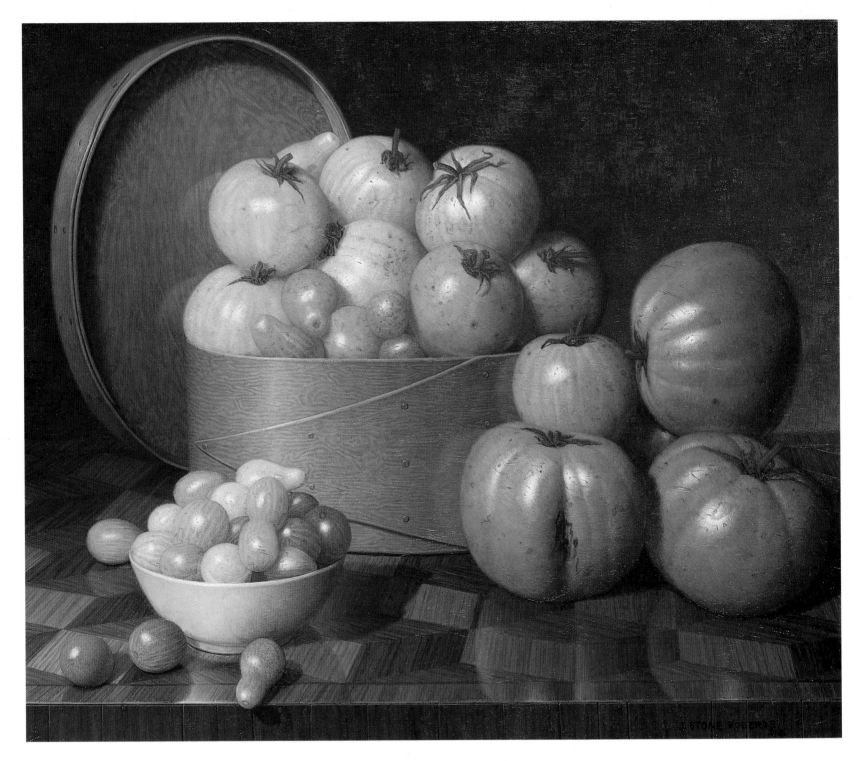

YELLOW TOMATOES
1987/88
Oil on canvas, 18 x 21 in.
Collection Mr. Jerald D. Fessenden

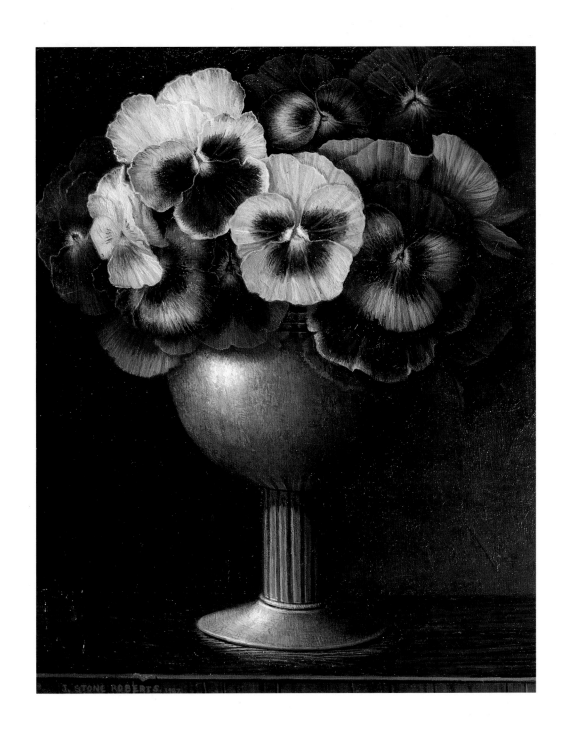

PANSIES IN A GOBLET
1987
Oil on paper, 9⅛ x 7⅜ in.
Courtesy Wendy S. Hoff Fine Arts, Inc.

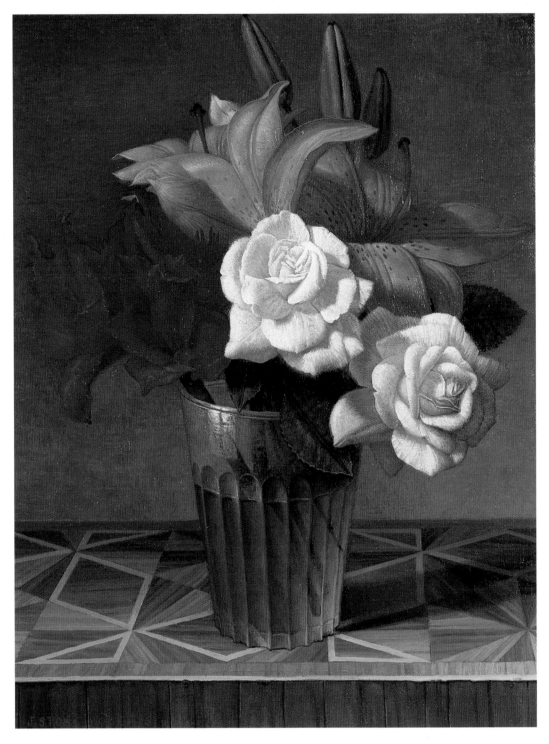

FLOWERS IN A GLASS
1987
Oil on canvas, 13 x 10 in.
Wellington Management Company Collection, Boston

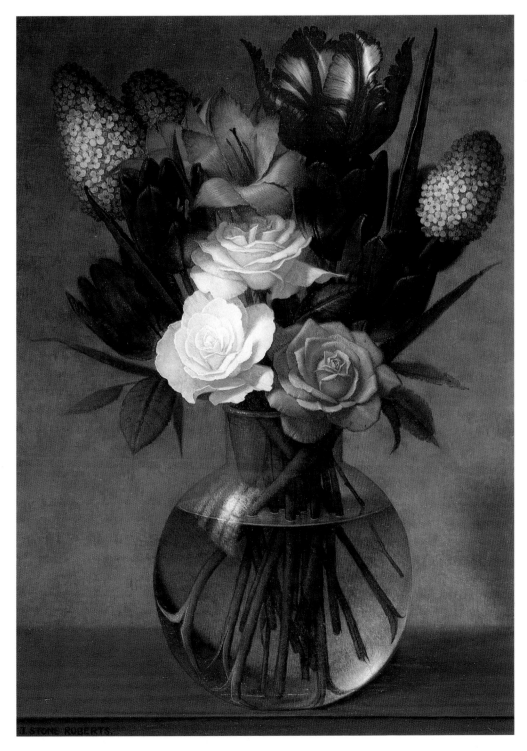

WINTER BOUQUET
1987
Oil on canvas, 21 x 15 in.
Collection Mr. and Mrs. Graham Gund

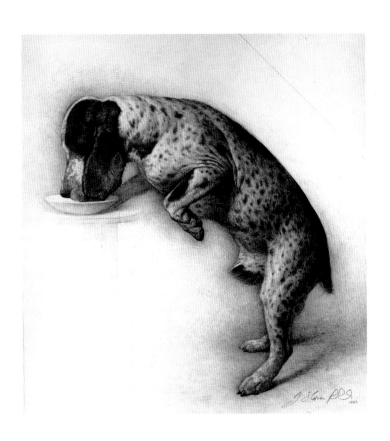

Study for LUKE AND FLOWERS
1987
Pencil on paper, 10½ x 10 in.
Private collection

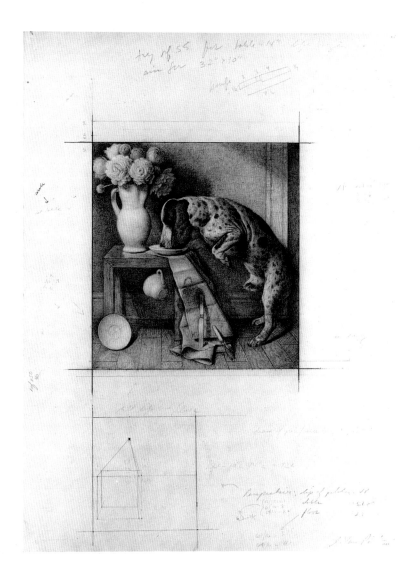

Preparatory Drawing for LUKE AND FLOWERS
1987
Pencil on paper, 15 x 11⅛ in.
Collection Mrs. Robert Schoelkopf

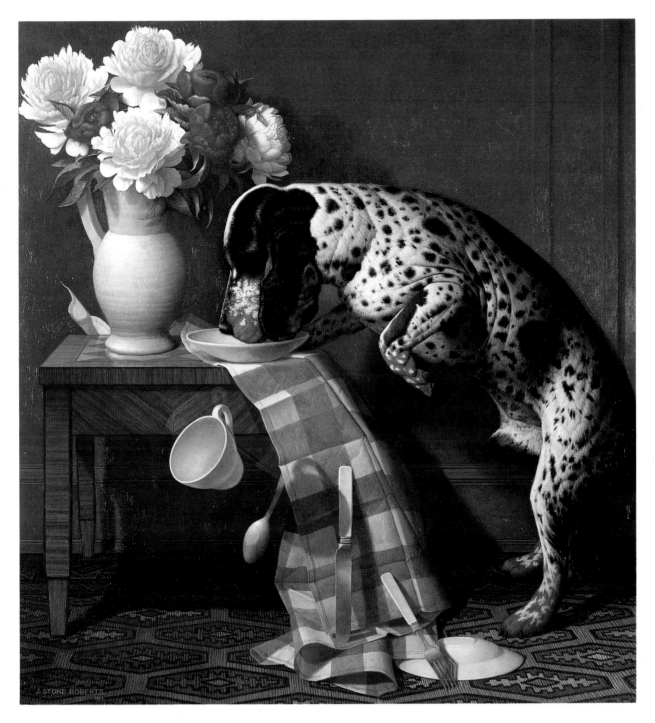

LUKE AND FLOWERS
1987
Oil on canvas, 32 x 30 in.
Collection Mr. and Mrs. Julius Rosenwald II

Study for PORTRAIT OF THOMAS AND LOUISE MCNAMEE
1988
Pencil on paper, 14½ x 10½ in.
Private collection, New York

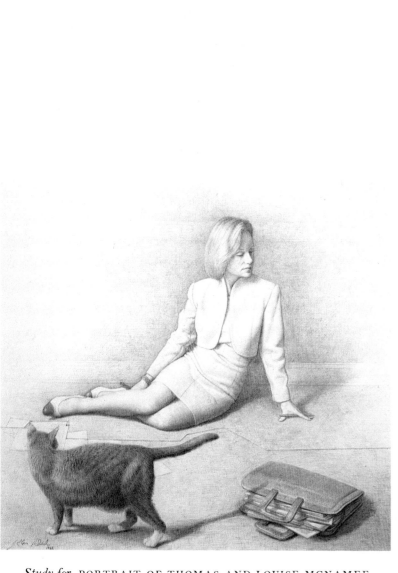

Study for PORTRAIT OF THOMAS AND LOUISE MCNAMEE
1988
Pencil on paper, 11 x 12 in.
Private collection, New York

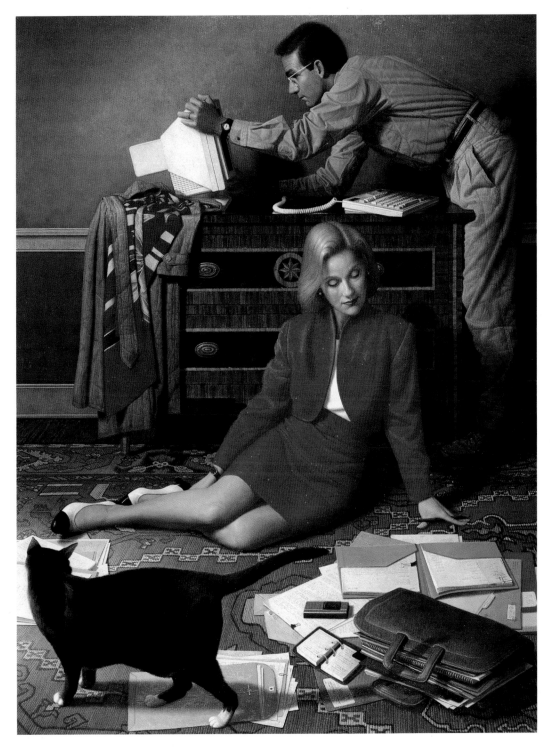

PORTRAIT OF THOMAS AND LOUISE MCNAMEE
1988
Oil on canvas, 47 x 35 in.
Private collection, New York

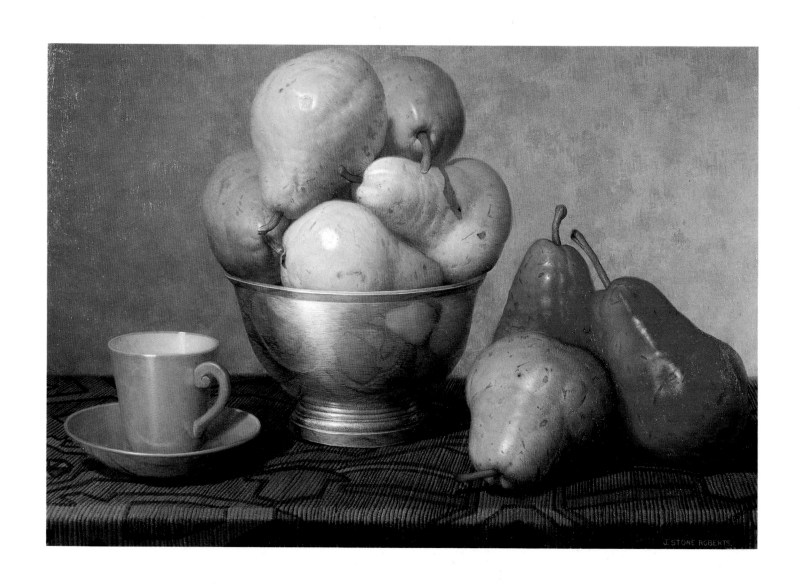

PEARS
1987
Oil on canvas, 16 x 23 in.
Collection Mr. and Mrs. Alan J. Hruska

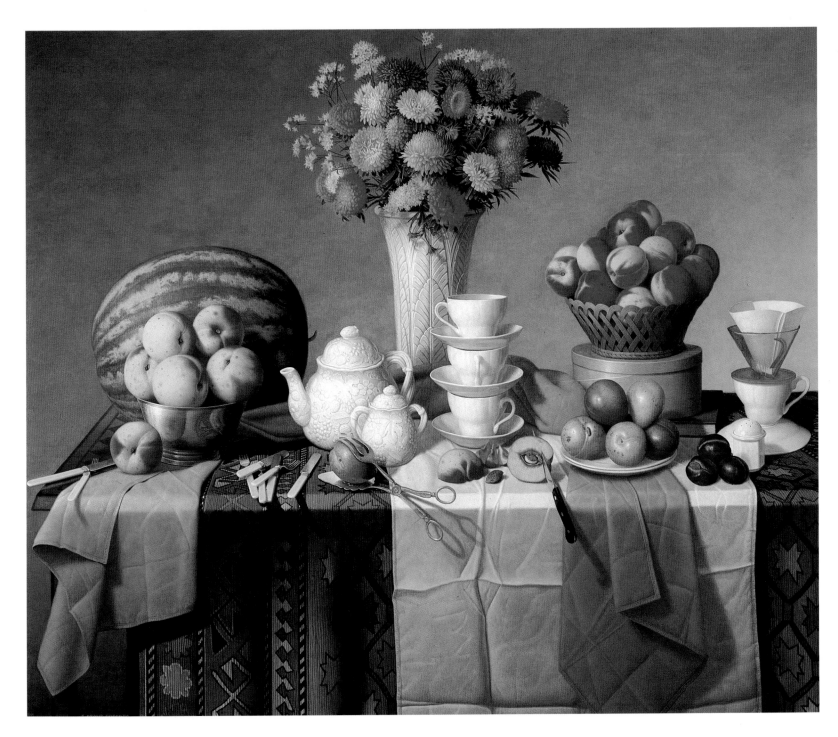

AUGUST STILL LIFE
1989
Oil on canvas, 46 x 54 in.
Collection Mr. and Mrs. Alan J. Hruska

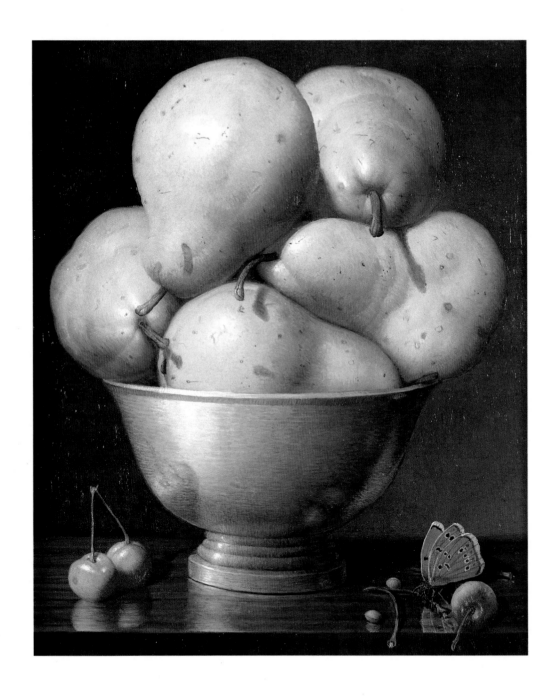

CHERRIES, PEARS AND BUTTERFLY
1989
Casein and oil on paper, 10½ x 8¾ in.
Collection Carl Spielvogel and Barbaralee Diamonstein-Spielvogel

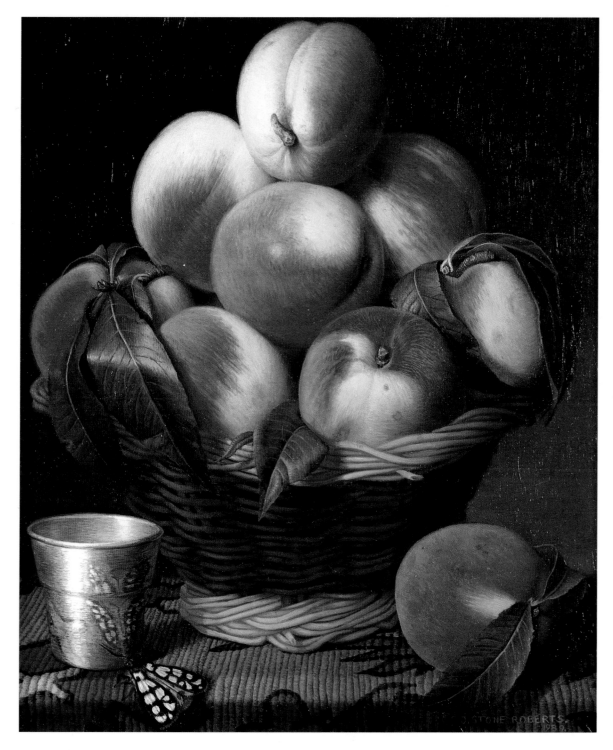

PEACHES, MOTH AND SILVER JIGGER
1989
Casein and oil on paper, 10½ x 8¾ in.
Collection Carl Spielvogel and Barbaralee Diamonstein-Spielvogel

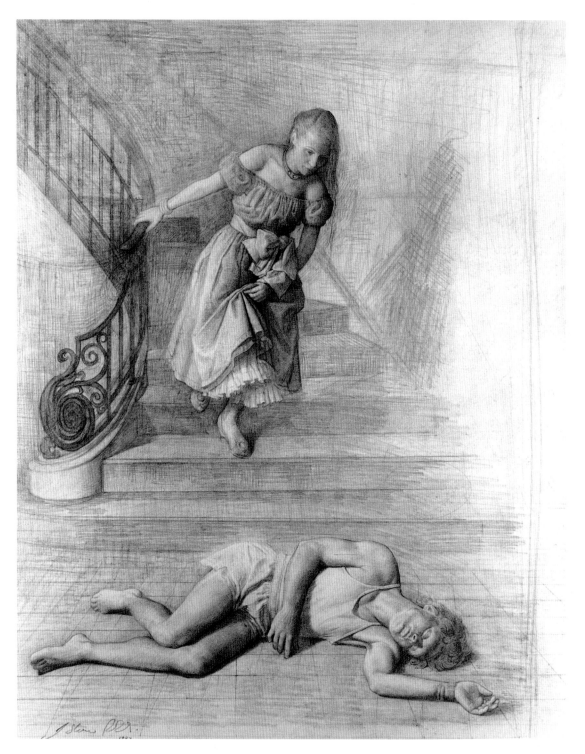

Study for VENUS AND ADONIS
1987
Pencil on paper, 12 x 9½ in.
Collection Regina A. Trapp

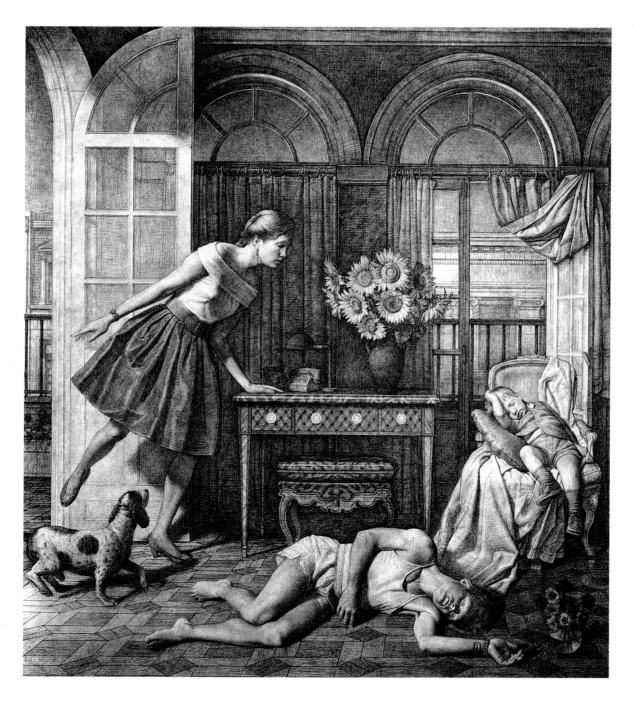

Cartoon for VENUS AND ADONIS
1987
Pencil on paper, 16 x 20 in.
Private collection, New York

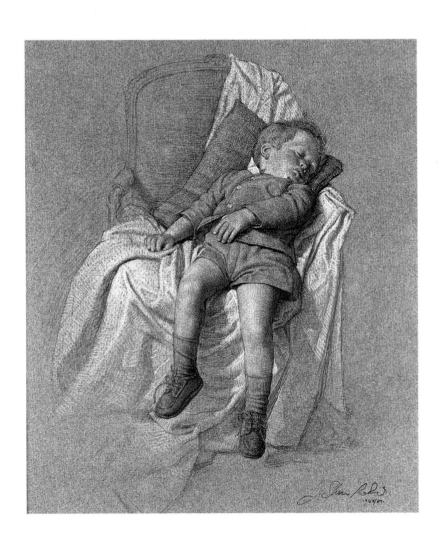

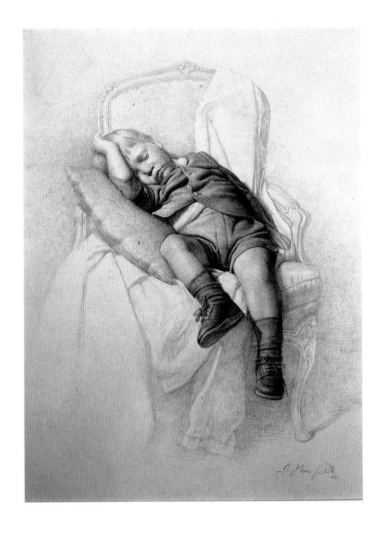

Study for VENUS AND ADONIS (*David*)
1987/88
Pencil on paper, 14 x 10½ in.
Collection Carll and Diane Tucker

Study for VENUS AND ADONIS (*David*)
1987/89
Pencil on tinted paper heightened with white, 11½ x 9¾ in.
Collection Stephens, Inc., Little Rock, Arkansas

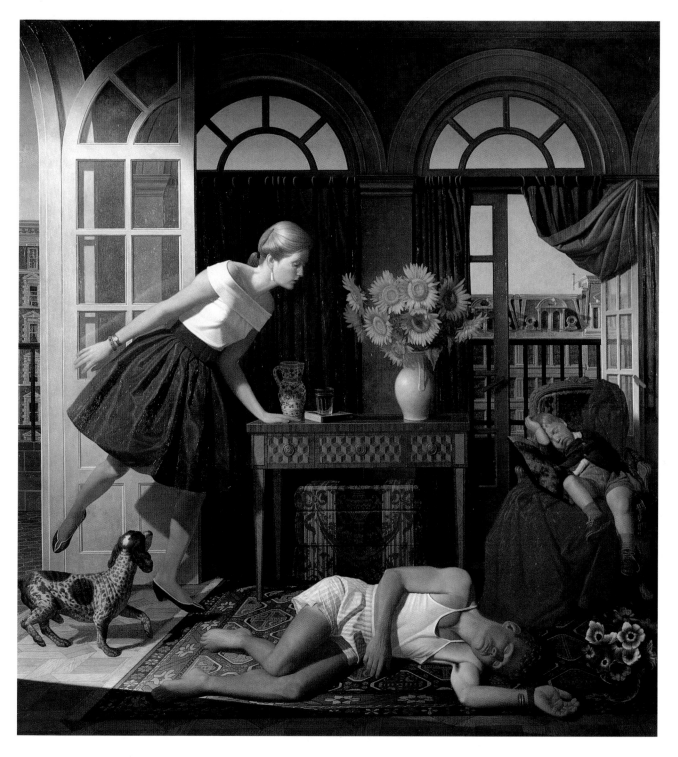

VENUS AND ADONIS
1987/88
Oil on canvas, 72 x 67½ in.
Private collection, Greenwich, Connecticut

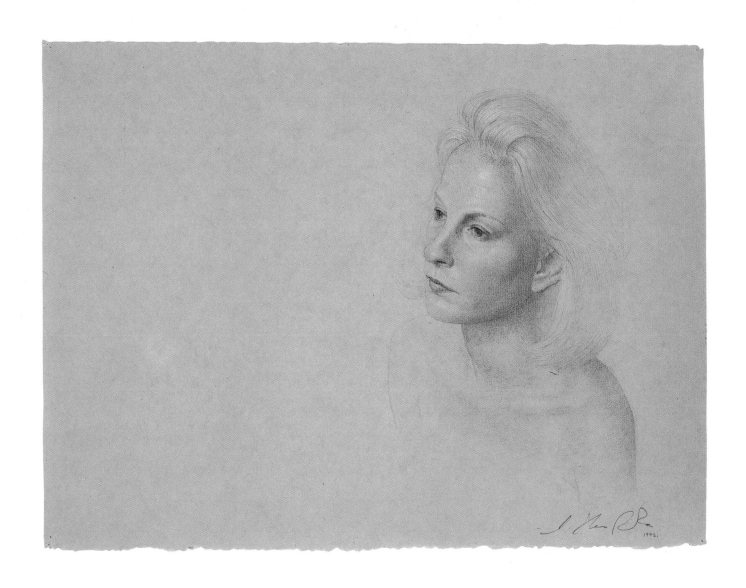

Study for PAUL AND CARO, *1992*
Colored pencils on tinted paper, 11 ⅛ x 15 in.
Courtesy Salander-O'Reilly Galleries, Inc.

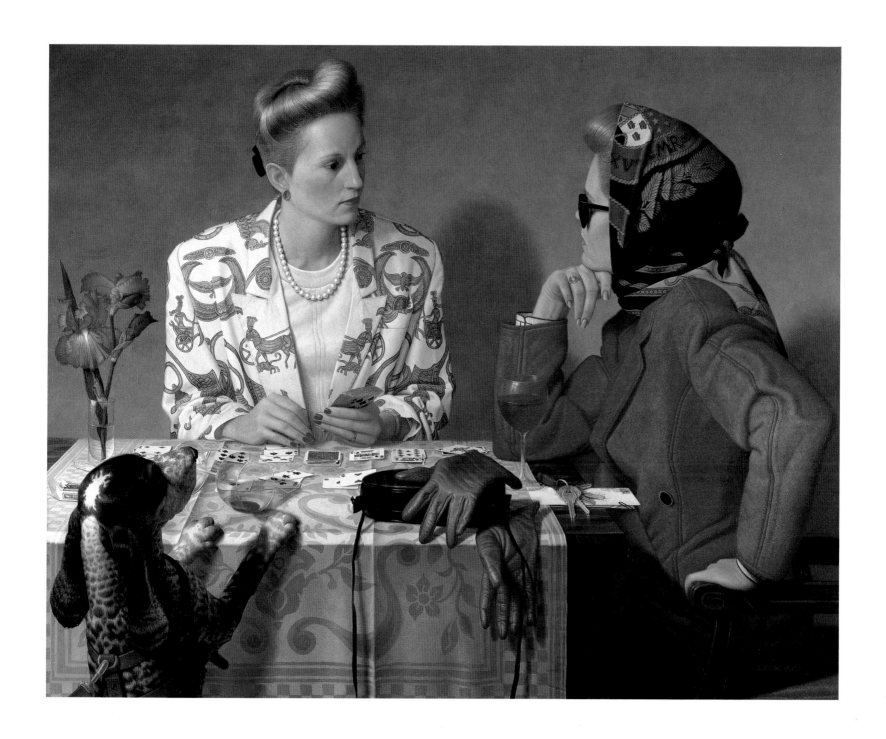

THE VISIT
1989
Oil on canvas, 37 x 45 in.
Collection Sydney and Walda Besthoff

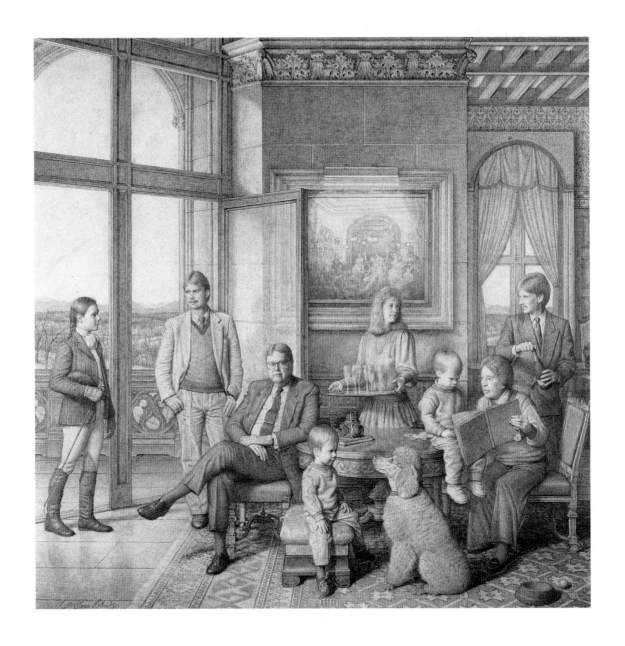

Cartoon for THE WILLIAM A. V. CECIL FAMILY
1990
Pencil on paper, 20¼ x 20¼ in.
Biltmore Estate, Asheville, North Carolina

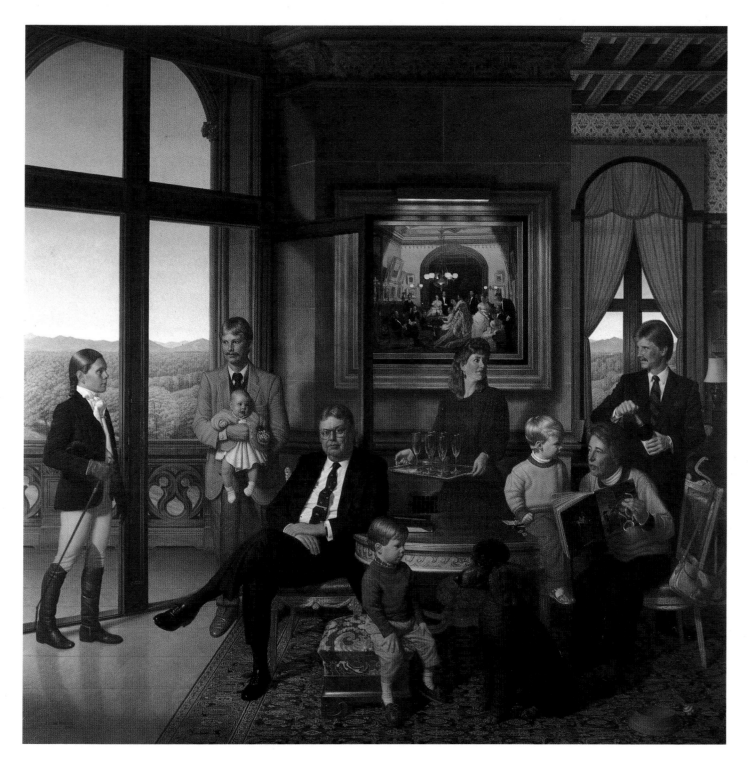

THE WILLIAM A.V. CECIL FAMILY
1990/91
Oil on canvas, 81 x 81 in.
Biltmore Estate, Asheville, North Carolina

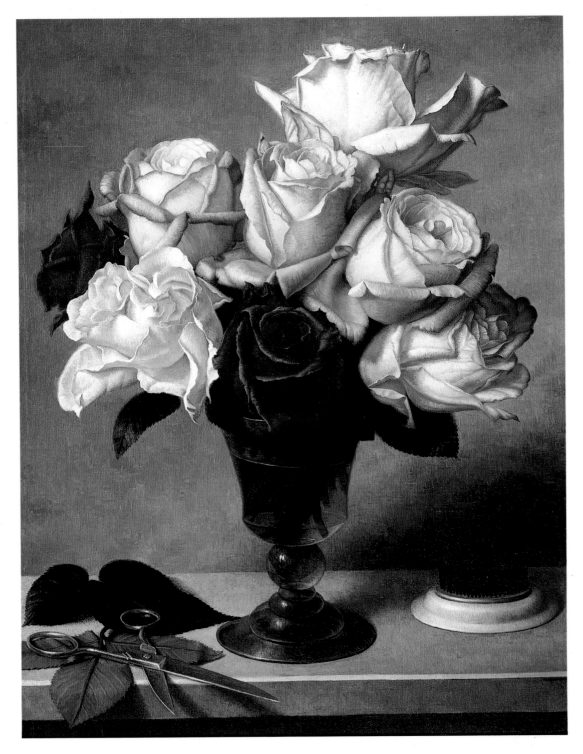

SCISSORS, FROG AND GARDEN ROSES
1991
Oil on canvas, 16 x 12½ in.
Collection Mr. and Mrs. Richard L. Menschel